Love vs= Weed

SHIVI GOYAL

Copyright © 2019 Shivi Goyal

All rights reserved.

ISBN: 978-1-7020-0326-1

PREFACE

Weeding out your better half will not solve the purpose. The point is to remain in sync. What we all do in our lives is completely insane at the time and then we keep on hovering to our minds on what to do and what not! Very honestly this book title will amaze you or may lead to some apprehension in your minds about love and weed. Don't let the title hurt you or offend you instead go deep into it and feel the pain, love, lust, highs, lows, wellness, sadness, and almost every feeling on this mankind – just in two words **LOVE vs=WEED.**

The Good-ship of this small book will take you to an entire journey of life that encompasses love and only love. Do not misunderstand the word weed as you will find how weed is a genre of love and vice versa. Weed in this book is more than just a blogger pseudonym. For me, it is very special as I started my writing journey from blogging. Long way back then I remember people used to talk rubbish and would quote and bully me for just being not that great in English and writing. Ahah! This chick will not gonna do anything and would just end in a piece of shit.

Like anybody else even I had my share of toxic relationships like a toxic weed. The healing will certainly be not easy and understanding this, after many years I realized what was hidden in me. I have always dreamt for a book that will pen down my heart out. But you know things don't go that easy in your way. This is my first book and is an attempt to the same. I want my readers to be honest with me when they would read it. I want them to connect with the verses, write up or thoughts that may relate to all. It took me time for a lot of reasons and have been pushed out maybe because writing doesn't pay good or the responsibilities on my shoulder, haha, maybe still not, but words are the ideal medium to express when your silence, actions and signs fail. **"SILENCE IS ALSO A WORD"**.

I would like to end saying that if you are a weed nerd then be like a love nerd. Nourish your life and love like a weed. Get stoned in positivity, get high for desires and happiness. Be headstrong and cure the pain not with aggression, anger, anxiety (prominent effects of marijuana in usual), rather take the positives and heal the world with pure love.

This book doesn't imply or suggest any medical or smoking weed in any form. My only agenda is to connect the stoners in the right way and tangle their feelings with love. The words entwined suggest that love is like weed or whenever we are dubious between love vs weed – choose love. In the end, the world needs love. It is a sheer expression of the author where weed personifies to love and life. But the experiences and feelings are real-life moments and incidences that had made me write this book.

"I just have you and your memories.

She said Thank You!

With her eyes drizzling"

CONTENTS

1	Abstract	11
2	Love in Its Purest Form	13
3	Love Hormone	15
4	Miraculous Love	16
5	The Page Unturned!	18
6	My Friend	20
7	Let's Sleep	21
8	The Spell of Love	25
9	Toxic Experiences	27
10	Toxic Love	29
12	Orgasmic Love	30
13	Intoxicating Love	31
14	Love Whispers Like Weed	35
15	We Still Try to Be Happy	37
16	I Wonder How Is She Alive	38
17	The Goodbye	42
18	The Wait	44
19	He and She – The Remembrance	45

20	Afterlife	47
21	The End	48
22	Get High in Love!	49
23	Something Crazy	51
24	Stay for A While	52
25	Beam of Light	54
26	Never Forget Past	55
27	Pain and Suffering	58
28	The Journey - The Tale Doesn't End Here	60
29	Love Burns	62
30	Love Doesn't Exist!	63
31	My Choice of Pain	64
32	Give It a Try	65
33	My Love	67
34	Love That Stinks	69
35	She Is a Healer	71
36	The Major Missing	74
37	Then…I Missed You!	76
38	Shades of Love	77
39	His Lady	79
40	Fallen or Risen	80
41	Numb	82
42	The Pride the Wish	83

43	Love and Lust	86
44	Lusty Love	89
45	The Mole	90
46	Rhythmic Weed Love	91
47	Lust Dynamic	93
48	Contagious Love	94
49	Your Lips	96
50	Acknowledgement	99
51	About the Author	107

Abstract

Shades of a poison, Called Love

For me, this book is very special and the first one of my life. My life has been a roller coaster of love and hate. Relationships have been bizarre for me all through my life. Single mother of a nine-year-old daughter takes me through a rough patch of my life, where I have struggled and still struggling for my livelihood. Post trying professional options, which at times did work, and sometimes didn't. My passion for writing never failed, but due to the financial crisis, I could not take it over to the next level.

The idea of coming up with this topic in my first book, as I have mentioned in the preface as well, was pretty clear. I wanted to express the shades of love in all forms. I may have missed a few as love is immortal and consist a universe within Like – **Love of Radha & Krishna and Love of Krishna & Meera.**

The shades of weed are equivalent to the shades of love. It is considered that everyone has a hankering for romantic love but only a few of us realize that love comes in a package of vivid shades that makes our life absolute. We all have these elements of love within us and we desire and challenge our highs and lows with a kick of weed, which in turn leads us to unconscious turbulence. **Whereas, according to Buddha love has four forms – Karuna (compassion), Maitri (kindness), Mudita (happiness), and Upeksha (Freedom).** On the other hand, as per our modern psychology, love and relationships have 7 types. What I wanted to mention is, whatever the glimpse we get and learn about love in our lives, we always try to hold it by all means.

When we go deeper and get stoned, we understand the real depth. My attempt from this book is to highlight the major elements of love and weed together in the form of poems, small verses and some hard-hitting quotes, so that my readers would relate to each and every word peened. I request my readers to please be a critic and the lover of the words, as this will give me the motivation to write more and bring up the feelings in the raw form. You will find yourself stuck in an array of elements like - sorrows, pain, sensuality, romance, passion, hatred, anger, rage, loneliness and so on and so forth.

Love in Its Purest Form

We wonder and kept thinking that if love exists, does it exists in its purest form. To the matter of fact, we couldn't get the desired answer though. This section of my book will shed some light on the aspects of pure love which we all miss in our lives, but trust me it does exist.

Love vs= Weed

Love Hormone

The love hormone and weed, go hand in hand

Both of them makes you comfortable and at ease,

The bond between the hormone and the weed is unconventional

We get personal and close clinging to our loved ones like weed

And when the oxytocin releases it mixes with the bleed,

Our hugs and weed become one then…

Well, both makes you comfortable and give an earth-shattering experience.

Miraculous Love

Stay close, stay near to my heart, stay to the one who knows you, your way;

Come close into the shade of a lush green tree that dispels the freshest flowers and blossoms love,

Please don't saunter frivolously through the bazaar of the fragrance markers,

Rather just be close to me that no one else can see...

If you are unable to find true balance in love, anyone can deceive you;

Anyone can trick you out of a thing of straw,

And can take you for granted,

But when you are a round life seems to be blissful,

Every touch of yours is like a sea pearls.

Love vs= Weed

Please don't squat out on a boiling pot;
Just be there like a love of fire you within,
We'll make life beautiful with trying out different things.

As not all sugarcanes have sugar, not all gulfs a peak;

O nightingale, with your voice I go crazy and lamenting,
Only your drunken ecstasy can prick the rock's hard heart,
I surrender to your soul with welcoming companionship.

Full of love I put my arms around you;
Kissing your forehead subtly and saying it aloud,
That you are mine forever, please be there,
As I want to die in your arms,
Because, I want to live again my dream.

Take me, love me, steal me, pamper me
Because, our love is miraculous!

The Page Unturned!

The turn, her life took, she did not imagine

Unable to decide what had happened

She was all on her own again

She tried to pour out with grit

She succeeded in lying to herself about the battlefield

She was a free spirit, concealed in a cocoon.

Now though she has got the mate for a lifetime

To let her perky soul breaks the prison of her own destiny

She found herself once again….

Thou silver divinity of clandestine night,

Straight my footprints through the tree shade;

Thou sentient spectator of an unknown delight,

The Lover's godsend, and the Muse unite!

Love vs= Weed

My Friend

I travel through your veins in and out My Friend
I loose myself to you when you're around or not My friend
As no one can, I'm there for you, forever.

Merging into your soul I will be all in you, as your breath within me makes me wild
You love me or hate me I promise to be secretly within you united like no one
In every inches and milliseconds, you will find me.

In every good or bad phase, I will be there... My friend
Nothing in the universe can't make me feel low if you are in me
Thus, I travel through your veins in and out My Friend.

Let's Sleep

Let's drop all worries into each other arms

You on top of me or vice versa

My hands embracing your waist close to your torso

You are holding my face

My legs tangled in yours

My eyes stuck on you and yours longingly on me

You are delicately wrapped in mine

And deeply looking into me

The dreams will keep searching their space

But we both kept on loving each other in the sands of time

Let's sleep in love!

Love vs= Weed

Love vs= Weed

Falling in love with you was not in my hand

Though I never wanna be in love again and love myself

I wasn't expecting this to happen

But sometimes falling in love unexpectedly

is a sweetener

Like a dipped dark chocolate post weed!

The Spell of Love

This love is crazy
Startled by his moves
Feeling over mountains
Like a bear freezing
This sounds a bit crazy
Not me the bear freezing.

I find life like a spinning ball
Moving in forwarding motion
My feelings are out of control
And free-flowing all through the terrain
This love which engorges
And let my heart skip a beat.

This insane love
No idea how to control my feelings
Who will be there to guard them
She kept thinking while humming
The sounds of passion.

Love vs= Weed

The sudden chill made her
Abandoned virgin and open
For vulnerable actions
She doesn't know what is coming next
Her intimidating love was a pure fascination.

Knowing that it is not physical
She loved every essence of him
The compassion, the elements, the assets,
The division, the shine and vivacious smile.

The smell was a sweet emotion
Certainly, love was in the air
With all the tenderness and reverence
This love felt insane and crazy
Now let's begin the story...

Toxic Experiences

If life is beautiful, it is toxic as well. The cover of the book implies the connection of love with weed and here you will be amazed to read the elements of toxic and painful relationships which we all go through in our lives. Just a few… More will come in another part of this book.

Love vs= Weed

Toxic Love

No love exists in this world without intentions, expectations and of course situations

He too had a few, but she couldn't take the fake/dualism

She broke, she cried in vain

She went into a den of dark clouds surrounding her soul

She was in deep sleep

But, he still was hoping to grab her in the name of love as toxic as weed!

Orgasmic Love

Try to give her the peace of mind, fulfilling her orgasmic needs
She is worth of this moment and will die for you
Her love is insane and infinite to the core
When you touch her she will be yours
Your blow would make her feel high

She will be stoned by your intense caressing
Instead of a broken soul in tears
She would fly high and will get a space to grow
With your orgasmic love towards her!

Intoxicating Love

Intoxicating, it's like a drug

Your scent, I breathe you in, my world, lights outs

You make me scream; you make me shout

When in doubt I look to you

You make my heart beat fast, it's true

Undo me with your touch

Seduce me with your smile.

You turn me giddy like a child!

I giggle while I play with your hair.

You know I can't help, but to stare.

Intoxicating you're the sun and I'm the moon

I'm Venus and you are Mars

Love vs= Weed

You shine brighter than any other star
But our worlds are so far apart

I knew I was a goner right from the start
I felt sad when you depart
I smile, and give you one last look.

You stole my heart with a reel a hook
Better than any book
Intoxicating my drug.

Love vs= Weed

Love vs= Weed

Pure love is like a religion

Weed gets you trippy to follow that religion with honesty

Then love becomes a weapon for your religion

So, love and weed entrusts peace to your soul and mankind

Love Whispers Like Weed

To send this message of love to you
I stare up at the moon
And whisper words from my heart so true
I miss you, sweetie, please come soon
The afternoon grew darkening from the west.

A silence fell on the air, and in the trees
The clustered birds pronounced their predictions
The flowers bent their heads as if to rest

Now that the tide of the sun's golden seas
In one long wave swept off the earth's wide breast.

Up leaped a clever shadowy patterns by grades
And nature face her soul evidently

Love vs= Weed

In the instant, slant, like a hanging string
Of silver glass beads, pendant from the clouds
The rain descends! Leaves sing, and wavering
The tall lithe grasses dance in separate crowds

I stand and let my soul commune, it knows
The mystery that calls it from its close.

We Still Try to Be Happy

How can I defend myself for not being a feminist?

How shall I be insisting on going in the right direction?

When you are into a relationship

Is there a measure of right or wrong?

Is there something which will tell us?

That this will work and this will not

We keep on looking for an angle to defend

And defy our egos and emotions

We shout we yell, we kick the walls

In a very self-centered manner

We make things more complicated.

And then we become a narcissist

Lost in the long run we still try to be happy

And keep people happy around us!

I Wonder How Is She Alive

How stimulating our lives can be
For years she buried the darkest secrets of her life
She hid her emotions by not telling them to anyone

Why?

Thinking she'd fail in the eyes of others
Thinking she'd drown herself deep dark in a black hole

Why?

Because it was her decision
She kept on telling her heart
To forget all assuming it a shit dream
Yet it would hover her mind
Reminding of what all toxic happened
The secret which she kept alive for years.

Love vs= Weed

Came to life, with her depression

What was hidden from all the prey

Was now world open stimulating her stress levels

I wonder how is she alive.

Love vs= Weed

Your love is like a weed to me
The more I get deep inside you
I trip high to infinity

But now:

I'm not afraid to tell you, that your breath stenches

And you're full of shit!

You have more exceeding deceits about your life than the bodies underneath your bed...

The Goodbye

Numerous nights have been passed by
With my face on my pillow
And body under my quilt,

I have no idea how many nights I was awake
How many tears fall from my dark brown eyes?
Before I lay down to sleep,

With a heart-full of betrayal and assault
It was tough to cope up in the relationship
She then felt aloof from the world,

Her shadows crept through the walls
Her identity was on the toss
Her spirits were taken to a toll,

Love vs= Weed

Then, she broke up one day
Catching up eyes with him
Telling him to be away forever
And stop being an asshole
GOODBYE!

Love vs= Weed

The Wait

The wait, is for our desires, our dreams and our aspirations towards the love of our life. The verses in Love in its purest form are related to waiting as well. you will find your soul and dreams getting wings while reading these short verses. The conversations here, will bind you to stay…

He and She – The Remembrance

She said that she doesn't remember him
She said that she tries to recall old school days when they were buddies
Shying genuinely with a blush on her face unable to recall him.

Those eyes which used to have tears before meeting him
Were, glittering waiting for something good to happen.

His heart used to sink after seeing her tears
Which, she used to hide in her beautiful smile
He can go to any length to make her smile.

He took ages and courage to break that cocoon which she treated as her home
And thought as the safest place to hide.

Love vs= Weed

She said that she was out of cocoon after meeting his buddy whom she found for her lifetime

Now they are standing at the same place where he met her few days back where she is trying to hide her tears in her atrocious smile.

His heart is sinking thinking she won't be the same person again
He has lost her again and can see her standing alone in the crowd.

Afterlife

Remembrance of nocturnal things which took me away from my world.

Now slithering and said: she isn't mine, she's being neutral, she's messing up, and so will I?

Ohh! MrMoon: the warmth of your skin, the breeze of your crescent and the silken arms around me

Is the symbol of Afterlife where there's no one, who could ever enter our own world of love and passion?

It is where the full moon and You and Me meet!

The End

Wondering where life will end
Looking at things from a tint in the window.

Perhaps not able to recognize what life is asking me to do
Or am I fool enough for not comprehending.
Whether it is a delight to meet him or a disaster
Which life told me some odd years' back.

Thinking that he can be the one
With all the struggles and fire absorbing deep
It ended in grief and sudden death of respect.

You know the reward and expectations tear us apart
And this is when the gates were shut for love
But as they rightly say, this is where afterlife beings.

Get High in Love!

I will remember the reflection of myself in your eyes
As when you kissed me your eyes were shining
I looked up to you for long - that long which I don't remember
I couldn't look away from you and keep thinking why you are in my life
Your talks make me remember that even I can live again
When I looked a bit far, you seemed to be still close;

And maybe just maybe, or it is just a sigh of life
That wanted you, to look at me and take me away
Every once in a while, for you to be rational of all the stuffs going around,
I'm there for you for all the realities and myths, to end the inescapably tragic life
I can stretch my boundaries for you, until you breathe my love.

Love vs= Weed

Something Crazy

Clueless life is like a lesson learnt

It makes you face; bravery, courage, agony, pain and love...

Yeah, you find yourself somewhere on the brim, still remain clueless...

Topping it with Love element, it is deeper

When it gets on your brain like weed, it is maddening

Isn't this slightly crazy? Or completely crazy?

Stay for A While

I love when you draw me near
I love when you warm me through my hushed and shallow voice
I love when you trifle my hair
The way you satisfy me
The way you read me, Even with the Sun flashing in the sky
Ohh My Love;

Your shades of love are continuous with me
Your unimaginable power and endurance gives me the strength to move on
Your belief in me kicks up the fire in me
I can't imagine my life without you! Stay!

Love vs= Weed

Silenced by love

Mind and heart seemed to be friends' forever

God has created us to spread love and happiness

Is it what we are doing

The beauty of our souls is hidden deep

But why isn't it coming out

Because we are silenced by love

And surrounded by toxicities

Beam of Light

Alter your ego and make it a place for kindness
Alter your ego and make it a place to forgive
Ego hurts
Ego changed our lives
It rages hatred and anger
It takes you to a road which is not taken yet
The poison spreads leading us nowhere
This No-land place is not where almighty is
She kept on doubting this
And then she saw a beam of light
Right within!

Never Forget Past

This past haunting life

This past doesn't let live

The nightmares of trauma are killing

They strangle us to death bed

Even the air feels heavy on the heart

Giving us a sensation of

Why are we alive?

The rotten smell of hate and pain

Never let us live!

We never forget our past love

The woman who has loved us more than her life

Her taste of a vintage wine

Her smile like a wind chime

Her gloriously red roses lips

All this are the past fetters

Gone by to death;

Love vs= Weed

But if this is a death

With a bride under a white sheet

Then what is life?

And where is life for her?

Every scar tells a story - every smile hides one

Pain and Suffering

Love can be painful and can bring a lot of suffering in numerous ways. My efforts here are to bring some forms of painful experiences which we experience in our love relationships. This journey of sorrows and endless tears has been constructed in the form of some beautiful lines in the coming pages.

Love vs= Weed

The Journey - The Tale Doesn't End Here

So this tale doesn't end here, with just the beauty of the first crush on her

She doesn't know about it until he admitted in front of her after 20 years

Who knew this will happen....

But they did not meet to talk about the crush, or what he read between the lines

And, he saw terrible pain and agony in her eyes
The eyes, those were wet while smiling
The tears, which wanted to be gushing out at any moment
Every breadth of her was engulfed in stillness

Love vs= Weed

She was all alone in the crowd, being with the crowd

He was puzzled to see the shakiness in her voice

When it was about Love when it was about respect when it was about profession

He was shaken……

Love Burns

The beautiful thing about love is, it hurts
Pain is the first things we experience in love like no other way
I will be not wrong to say or probably much too late
That trying an apology and learning from mistakes
Is what love needs?
But what we lovers do?

We buy flowers, we buy gifts, we try to amend it with glitter
And you know what?

It fails, it terribly blows out maximum times
So what is needed if we wish love to not hurt
Hold hands, sit beside, give your beloved all of yours
When there's a chance grab into arms
And do all those little things which will make your love set free.

Let the love dance overall and forever
Being together eternally will never hurt.

Love Doesn't Exist!

There's no love exists in this world without intentions, expectations and of course situations
He too had a few, but she couldn't take the fake/dualism
And went into deep cave
Got herself stoned for not to reminisce him
She thought it would protect her from getting destroyed in love
Rather it took her heart away to him.

My Choice of Pain

My choice then why feeling nostalgic

My choice then why in agony

My choice then why wanted to be on a death bed

My choice then why low on confidence

My choice then why creepy thoughts crawl my mind

My choice of love then why, keep lingering for love and respect

My choice of love then why to hurt your soul

My choice then why looking for a companion

My choice then why reluctant to speak

My choice then why helpless

Why, why, why……

My soul leaves me sick!

Is making our own choices and taking a leap in life is unethical?

Give It a Try

Love can't be measured in hugs and kisses

It can't be calculated how many times you say I love you

Why we try to love in chains of ifs and buts, you and me, me first, you first...

Give love a try eternally asking your emotion true questions

Give love a try to lead the pure way

Why we hesitate expressing love

Why can't we bleed in love?

Why can't we?

You need alcohol to say "I Love You"

Apparently, I Love You itself is a weed!

My Love

My love will never get old
My love will never get pale
I will always have my trial and error
I will always get those magical moments
I will always have him beside me.

So, when all this happens
And the promises are being made
Why the pain flows in my veins
My blood has become my pain.

These trails in love have defeated me
My emotions are biting me
Will this pain be forever?
Will I never get a chance to be true again?
Will I never get 'Me', back?

Love vs= Weed

This insane feeling of broken heart kills me
Asking me - Am I a bad soul
Now the love and pain is mutual
The neglect, the misery, the interference
Is this love?

I think unconditionally loving is giving me sorrows
And then I think Nah, he is mine and I love him
But is it only for the sake of being loved
Or do I have unconditional respect
This painful journey needs to end
When only the Almighty knows!

Love That Stinks

She woke up with a smile on her face
She remembers she used to wake up with her footie warming pyjamas
She upchucked the whole cooked meal
She felt helpless and dizzy and then what
She realized her foot on the ground wet;

Wet with blood drops and stains on the bottoms
She felt terrible pain to get over this emotion
She wondered! What the fuck!

This doesn't seem easy to me
Is it the last night love?
Or it was brutal love or rape
What to call this was a task in her mind;

Love vs= Weed

Like you get away with your toothbrush in two-three months
She'd feel the same, hanging on every single word being told to her
She'd push her to think wise and nice
But she retires her love today saying that it stinks.

She Is a Healer

My existence has become a pain
The more she lives the more she lives the pain
She wants to die she wants to kill herself.

Thinking that she is a piece of shit
She is a lo
ver, She is healer, She is smile
She is like a soft petal by heart
She is kind, She is genuine.

But guess what
She fails when it comes to love
She fails when it comes to manipulation
She fails to become selfish.

Love vs= Weed

And when she is on her way to find the love she seeks for
She fails again
She fails to make a decision as those are judged by bystanders
She is judged for her open speech that says the truth on the face
She is considered to be fake and cruel when she is outspoken
She fails to be a fit among misfits.

Because she doesn't like to gossip
Because she hates sugar daddy and sugar-coated talks
Why is she like this – is the question she keeps on asking to herself every now and then
Mythically, she considers her existence to be a pain.

Love vs= Weed

You are like weed for me

But you thrashed, crushed, and took me raw...

The Major Missing

We all miss quite numerous things and people in our lives. This missing can be real or in the dream world. When we experience happiness with someone, we tend to feel that why can't happy times last forever. This part is all about separation, missing, the void in our lives. What we need to do, is to rekindle our cherished moments and cope with the turmoil of pain we have faced. Read them all, I'm sure many would relate with the feelings and expressions.

Love vs= Weed

Then...I Missed You!

It poured heavily today
I could hear the thundering
The skies were changing colors with sounds of thunder
The cold winds blow touch my nose and sprinkle in my eyes
The rains today washed a new and little streams danced on the roads

I saw gulmohar petals drenched in orange and red hues
The tiny raindrops falling on the windshield sneaking his face within

Amidst all my heart spoke to you and yours to me
I felt the touch and felt you move besides me
Then (2) ... I missed you!

Shades of Love

Love has many forms and many meanings, which can't be defined and explained

One thing which is very important is to give space to each other and try to understand and evaluate the situations which are usually anybody's fault

Why I'm saying this today, have no reason but just wanted to quote something below:
Some people fight for caste, creed and religion while some fight for power, prestige or position.

It is only friends who fight selflessly, without any reason and for nothing
This is companionship that should be cherished always
This love which doesn't feels right at times is the strongest bond forever

Love vs= Weed

If you meet someone like this in your life
Do not let it go, hold it tight, as being there, standing by your side selflessly
Is the real love towards you!
Respect that, admire, because this will make your bond stronger and healthier.

His Lady

The mysterious moves plants something new
The footsteps lead to a way where,
I have plotted my way towards MrMoon
She replied to man who asked her "where are your footsteps leading to My Lady"

Fallen or Risen

There's something which is not good
There's something that's not right
There's something that's not going
There's something that's neither happening
There's something which I'm not able to infer
There's something which gives me goosebumps
There's a havoc which is killing me from inside;

Trying to understand
Trying to name it
Trying to perch through
Keeping the unchecked – checked
What is it? Wondering...
Where I'm again... Fallen? Or Risen?

Love vs= Weed

Life is like an unloved flower

Until it melts like a weed

Numb

She was numb all through the night

She wondered why is she being treated like this

She said in her mind: I want to spell it out with all my scars and flaws

I want to see my heart in a spoiled ink with strings of letters floating

Like a droplet of water from my fingertips

I want to throw out everything which is toxic in my relationship

Having tried and done with all

I got this four-letter word

Numb!

The Pride the Wish

The wish of my life
The pride of that one desire
To get fulfilled...

That one desire to hold someone close
One wish to be loved and respected
Of whatever my heart would ask me to do
That one desire to smile on everything
That comes my way...

That one pride to have you
For my life forever
When our hearts would fuse in one
If I would have to choose that wish
I would choose you
When our love would mature as an endeavor.

Love vs= Weed

I desire you stay with me eternally
Wish to be on your lap always when I'm low

Keeping you close enough like an angel
You are my heart's key, my pacifier.

Forever is a far, long time
Why not make it today?
I will write for you in a rhyme
With your command
My demand will be armed.

With your permission then
I would get lost in a kiss
Yearning to be upon a star
Far in deep space
Where my only aspiration is to love you.

Love vs= Weed

I aspire to be in you

With my bizarre performances

Seem to make you crazy

But this is a wish which I persevere

If I had one wish to make

It will be you!

Love and Lust

Lust is an integral part of love in all forms. Passionate love is something lusty in its way. But being lusty is not wrong, when in love. Lust triggers compassion and sensual traits in relationships. The idea is to understand it's niche, which I tried to replicate in this section.

Love vs= Weed

You are nothing like a weed to me

Now I know, now, why I lust you more than

I love you

Love vs= Weed

Lusty Love

I left him; I have to let him go

As lust and love together were clashing

As lust was overpowering, as lust became the boss

I have to let him go, I have to leave him go!

For him to move ahead and go to his commitment

As he was not committed to me, he was "just there"

Just There – where lust and love were not going hand in hand

Just There – where he would question me for not touching him.

On the contrary I was lusting on him to build a life together

And he was just there trying to be on me and passing time…

The Mole

The drops showered on your eyes

Calling my eyes to touch them with sensuousness

Eye lashes teasing my way away, tantalizing the oomph of a kiss

Lips wanting to delve deep in the Man's eyes

With passionate and intense kiss

The slippery soft lips now wish my tongue to get in the world of love

The nectar tastes like a sweet love, wanting more to explore

The French call it a French kiss

I call it the touch of his lips where the mole stares me.

Rhythmic Weed Love

Baby the way you hold me, the way to grab me in your strong arms, my sentiments makes it perfect
And tell me, how important you are to me, while you were close to me, while you were lying here next to me

When I snoop to your heart-beat in the pulse of my love, I go crazy and mingle in your breath
With every pound, my heart skips a heartbeat and throws that warming sound

To say that I love you every day and ever, to say that you keep me safe with your love in a treasure chest;

When you touch me, your soft hands tickle my skin
You keep binding me in your earnest cuddle, just where I know, I belong to

Love vs= Weed

You just hold me close and make me feel beautiful every day
Your embrace and touch soothe me all through the night
Until we both open our eyes to first signs of sunshine
Baby, I'm yours and you are mine;

Baby when you kiss me, my lips shiver in lust, but when you smooch me my lips tremble to give more

The bliss you convey to my heart, can't be expressed in words
You make my life so expressive, perfect, and soulful, that I don't need anyone in my life ever now…

You're my faith, dreams and desires, you're my everything.

Lust Dynamic

Life is an ever ending lust for love and affection
Then why misery??
You cannot say that misery is the ultimate truth
If lust overhauls your love
The killing thoughts of lusty eyes and arms around
The shallow breath piercing your earlobe.

Is this the affection we all thrive for?
Then why misery? Can't we stay on it?
Well, tedious affair!
Although, the ultimate reality is in almighty' s hand and your karma
Where there is no escapism!

Contagious Love

Moonlit falling on the bed
Making her body shine bright
She was wrapped up firmly in her soft silken clothes.

The melodies of her fragrance were all over the bed
She pulls her out in sickness of passion and compassion.

Her chest half lighten up with the white moonlit
Dripping the wool twine radiating her pale skin tone.

Her muscles and bones going tendon
Hiding all her gems beneath her well-woven skin.

She said to Mr. Moon I'm not a virgin anymore
She laughs and giggles to the bubble of air

Love vs= Weed

And breaks her heart on the sheet of cotton
She was so pure and sober on that sheet.

Her fingers cuddling the pillow
Her lips touching the soft cloth of pillow
Her heart and shape of the body melting on that sheet.

Like the twisted threads of her assets
She was so contagious in love
She laid in silence with her clammy skin.

Your Lips

Your lips say my name
To listen my name form your lips is hypnotic
It is delusional and can't express
How enchanted and devoured I feel
Your words hang loose leaving the expression behind
Your lusty eyes match with your lip movements.

They talk in bewitching ways to me
They talk to me radiantly with a pure awe
The mole is electric and has infuriating charm
Sends signals locking them with your illusion
I mindlessly stare at you with shyness all over
So, it's time then
For the love to flow...

I just have you and your memories

She said Thank You! With her eyes drizzling

And then there was Sigh of Silence!

Love vs= Weed

Acknowledgement

Life is a prologue, which allows us to pay our gratitude to those because of whom your existence is. This tales of never-ending journeys, this acknowledgement is close to my heart for a simple reason, this being my first ever book. I have no idea since when I wanted to write my book because my life is just the words which I write. My life experiences are in the form of a story. My travel tales are my life's dreams. My bucket list is a memoir of untold.

Well, now I would like to pay my regards and respect to the two in my life who gave me birth – My Ma and Papa. Their efforts and dedication made me the person who I'm today. Blessed with certain values which are exciting enough to kill the world with attitude.

They have taught me endless principles which I owe them today. My Ma is a pillar; she is the whole universe of energy around me. She has never asked me to turn my face on something I'm not liking, rather would put me in the front of it to fight. My Dad, who is an epitome of honesty and endurance.

His tolerance and stiffness to hard work have always supported me in my journey of corporate culture for 15 years. Nevertheless, these two – the reason for my existence have had all of me. From my first day at school to my broken marriage, they have seen all. I would like to thank them for being there and also for not being there when I was right on my notions towards life and society and they were not. Just because their times were different as ours today.

At times in life, you always get pulled back by the negative energies and you won't find a ray of hope. No matter how hard you push yourself every morning to rock the world but your destiny and time would not allow you to do so. There' always something unexpected waiting for you knocking on the door. And when this happens, you get devastated with the unforeseen imbecilities over time. What shall be done, nothing? Is it? We can't, right? As we all have to move on.

With my 32 years of life since when I have started getting an understanding of so-called – Good or Bad in life, I have been into this self-realization mode to know my destiny or maybe to turn around the way I wish to, with my karmas. But you know what I fail and yes, I did.

Amidst of this – there's only one smile in this whole world which give me a ray of life to stand on my feet again is my daughter – Dishita (we call her Chiya, she is 9 years 7 months now). She is full of life and is certainly a live wire with immense energy to shower. Well, no matter how much I shall thank her will not be enough but, she is the one without whom I could have not achieved and lived happy moments of my life. We live together for the past few years now, without my husband and during those years I have seen her growing stronger than ever, mentally and physically.

I have no idea what life I will be able to give her next, but with this book certainly, she will be dancing all over – announcing to everyone around her, that hey, my Mom is a writer and she has finally got her first book out.

I see her doing this, without knowing what will be the result of this book. But, her smile will make it up for all my tears and pain which I brought to write this book. **Woof... the goosebumps.**

If my readers would like to see or talk to My Chirping Bird – Chiya, you guys can watch her on Instagram;
@chiya_rocks
Facebook; @Chiyalittleangel

"The Most beautiful thing is to see a person you love smiling. And even more beautiful is knowing that you are the reason behind it."

Writing a book is harder than I thought, and more inspiring than I could have ever imagined. With turmoil and hurdles in my way and with hurricanes soaring over my life all day, all through, moreover, being a single mother was tough, in fact next to impossible.

With allegations and cruel eyes of the world on me and my daughter and jobless for months, having my account balance to zero, the responsibilities to cater too for family and my daughter didn't end. There were people whom I loved, who used to pull my back all the time. Looking at me, as I'm available for them, being a kind human it took time for me to say **NO** for things.

Bringing my own choices out in me, from being there to the moon and black, this is the person who triggered the whole idea of writing the book, which was almost dead in me for past 8 years. None of this would have been possible without this person's efforts and support. The irony of my life to meet that person in my childhood then vanished for a long time, and God made me, meet that human one day.

I call him/her as the God-Send (name not disclosed due to societal taboos), the flawless, kind and true meaning of a friend. God-Send personifies all the characters of a friend in need is a friend indeed. He/she stood by me during every struggle and all my successes, without demanding anything out of me or expecting, except the smiles of my daughter and I. True friendship has no name, no gender, thus, not putting the name of the person as, we in the society start judging and taking a toll for the person's character.

Intentionally not putting the name for the fact that I don't want the person to get humiliated by the jerks out there. Apparently, I would request you all not to judge a person by his, gender, caste, religion or his/her relations with etc. etc. etc. Yes, this is the mockery of our societies which are talked under the sheets, not in open, a glimpse of this you will find in my verses as well. **Thanks for being there, you are the stimulation for Love vs=weed.**

I want to thank **EVERYONE** who ever said anything positive to me or grounded me with life lessons. I heard it all, and it meant something, that's it. Special thanks to family, friends and relatives who have been extending wishes all through.

All the dudes I have ever been associated with, personally and professionally, who have taken a charge of my character horribly. I apprehend the encounters, but I'm not naming none of you!

I want to thank the almighty most of all because without whom I wouldn't be able to do any of this.

About the Author

I'm a juggler, a meandered soul and a rolling stone on the circle of life. I believe in the miracle of words and the rain. My favourite pastimes include reading, listening to podcasts, Netflix, and gazing at monsoon clouds and Moon. Travel is something I enjoy and has been to numerous destinations solo and in the group - for the love of meeting new people and discovering new cultures. Well, this is me in short but...

There is another me in me; a maverick who doesn't fall into the rules of life. I used to question my mother since my childhood on the stigmas of our society which they portray towards women. I realised a few years later that even she can't answer as she too has gone through many of them. With my life turned to incidences which I have never imagined.

I started writing a diary and gradually with time I saw myself peeping into those moments which I was not able to tell anybody. My married life and life before it gave me ample reason to write in my loneliness.

I have not always thought to be a writer though, but the spoiled ink within me and my life's experiences inclined my soul to write as words are the best friends and so as books. I had and made many!

Wait to know more about me in my next book, coming out soon. If you all like this one and felt the words close to your heart, please let me know as they will be a motivator. Also, my pillars are mentioned in the acknowledgment.

Being my first book, I'm pretty nervous and nostalgic, but whatever it is, I request my readers to read and love yourself in all the ways. Become a part in my journey where there is no right, no wrong, it is just **We All...**

Be with me on the followings platforms and leave your comments and suggestions. I'm looking forward to get honest comments and reviews.

Email: shivimuskan@gmail.com

Facebook Page: @SpiritedBlogger

Instagram: @shivimuskan

Instagram: @spoiledink707

Twitter: @shivimuskan

Goodreads: @shivigoyal

Website: www.SpiritedBlogger.com

Love vs= Weed

Printed in Great Britain
by Amazon